"Sharper than a Hanzo sword, more satisfying than a Big Kahuna burger, and more professional than Mr. Pink, *Shoot Like Tarantino* is a hit-and-run read, one that makes an impact and speeds off to its next example with hardly a second to lose. If you're looking to maximize your cinematic storytelling opportunities, this is a dynamite place to start."

— Glenn Dallas, *San Francisco Book Review*

"Christopher Kenworthy has filled this book with hundreds of tips and tricks that will help you make better movies whether you are new to filmmaking or are a Hollywood veteran. He breaks down scenes from Tarantino's films into nuggets that are easy to under-stand and are truly enlightening. Now you too can create unique and intriguing scenes to captivate your audience. Reading *Shoot Like Tarantino* is like sitting in a coffee shop talking film with Quentin himself... minus all the swords, blood, and Ninja body parts scattered on the floor."

— Forris Day Jr., Writer, Reviewer: scaredstiffreviews.com

"Kenworthy does it again with this short and sweet study of one of my favorite directors, Quentin Tarantino. Packed, as usual, with his easy to understand, illustrated breakdowns, this book is a must-have for anyone seeking to emulate the famed di

— Nathyn Masters, TimeCode Me

"I love this book! It's simple to
can't wait to use the lessons le

— Trevor Mayes, Screenwriter/Dir

"Great little book on a master visual storyteller by an astute cinema writer."

— Dave Watson, Editor: Movies Matter davesaysmoviesmatter.com

SHOOT LIKE

TARANTINO

The Visual Secrets of Dangerous Directing

CHRISTOPHER KENWORTHY

MICHAEL WIESE PRODUCTIONS

Published by Michael Wiese Productions
12400 Ventura Blvd. #1111
Studio City, CA 91604
(818) 379-8799, (818) 986-3408 (FAX)
mw@mwp.com
www.mwp.com

Cover design by Johnny Ink. www.johnnyink.com
Interior design by William Morosi
Copyediting by Gary Sunshine
Printed by McNaughton & Gunn

Manufactured in the United States of America

Library of Congress Cataloging-in-Publication Data

Kenworthy, Christopher.
 Shoot like Tarantino : the visual secrets of dangerous directing /
Christopher Kenworthy.
 pages cm
 ISBN 978-1-61593-225-2
1. Tarantino, Quentin--Criticism and interpretation. 2. Cinematography. 3.
Motion pictures--Production and direction. I. Title.
 PN1998.3.T358K46 2015
 791.4302'33092--dc23

 2014041069

Printed on Recycled Stock

CONTENTS

INTRODUCTION

Quentin Tarantino is a master of tension, suspense, shock moments, dazzling dialogue scenes, and offbeat humor. This book shows you why the best moments in his films work so well, and how you can take that knowledge to make your own films work more effectively.

You don't want to copy Tarantino. Hundreds of people copy Tarantino without understanding what it is that makes him brilliant and the result is usually a lot of swearing and pointless violence. When people copy Tarantino badly it makes for an embarrassing mess.

You want to be an exciting and original filmmaker, but when you learn the shots, shortcuts, and creative setups that Tarantino has mastered, you will become a better filmmaker. An understanding of how he works should give you more opportunities to be creative with the camera.

A huge part of Tarantino's storytelling comes from his screen-writing and the way he directs actors, but he has such an advanced understanding of screen language that he's able to tell stories more efficiently than most directors. The films explored in this book show that no matter how good your actors or your script, you need to explore the magic of the camera to make your story work on the big screen.

The scenes chosen for this book range from unforgettable master-pieces to more functional moments, to show that a good storyteller must make the most of the shot, whether it's the best scene or one of the minor plot points. One of Tarantino's strengths is his efficiency. He proves that you barely need to move the camera to tell a good story. He also shows that every moment counts, and far from being a director who lets scenes drift on for no reason, he guarantees there is a point to everything you get to see.

The chapters in this book will teach you skills that you can apply to your own films, making them a part of your own style. When writing this book I made a point of studying how the scenes work, rather than reading any background information. I didn't want to know any theories or legends regarding scenes. For you to get the most from this book, you need to know the exact technical reasons that these scenes work. The important point here is that no matter how creative or wild you want to be, you need to be a technician to tell stories well.

Tarantino is famous for many reasons, but he is underrated as a technical filmmaker. This book illuminates his talent for establishing character and story in seconds, or maintaining tension for unbearable lengths of time. This would not be possible if he was simply covering the scenes in the traditional way, with a master and a few close-ups. His films work because he's found ways to shoot that make the most of every moment.

I hope this book will show you that good filmmakers do more than shoot the scene that's in front of them. There are details in these scenes that show Tarantino's obsession with getting the best possible scene. He cares about film, and he takes the time to make sure that every angle, every glance, every motion and camera move serves the needs of the story.

Tarantino shows that some of the simplest techniques can lead to some of the most sizzling scenes ever shot. When you know how Tarantino creates these tense, dramatic, and shocking scenes, you can adapt the ideas to your own style.

By the time you have reached the end of the book you should have a good grasp of how Tarantino sees a scene, how carefully he sets it up, and how he films creatively. You'll be able to shoot your own scenes with a better understanding of the visual techniques that make a scene come to life.

HOW TO USE THIS BOOK

Watch every Tarantino film you can before you read this book and buy copies of the films that you can keep, so you can watch these scenes (and others) to decode the techniques. The chapters are filled with spoilers, so make sure you watch the films first. Most of the scenes are from relatively early on in the film, to avoid giving too much away, but you should still watch each film before reading the book.

You can work through the book in order, pick a chapter that interests you, or work through according to your favorite films.

The techniques can be applied to your own work. If you're creating a scene that needs unbearable tension, there's a chapter dedicated to that and you can go straight there.

Before you read the chapter, watch the scene in question if you can and try to see how and why it works. Then, once you've read the chapter, watch the scene again, perhaps with the sound down so you can focus on the camera moves and see how the scene has been crafted.

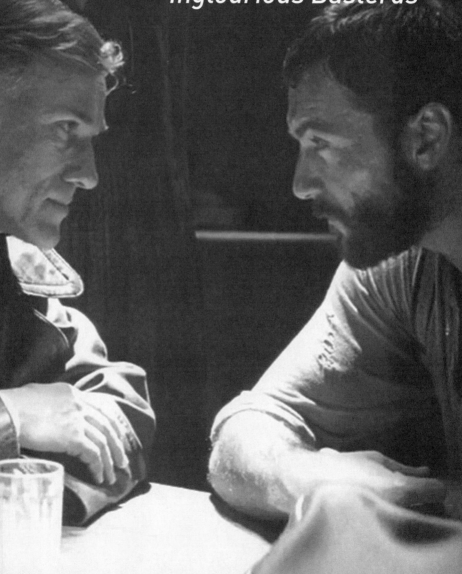

RAISING TENSION:
Inglourious Basterds

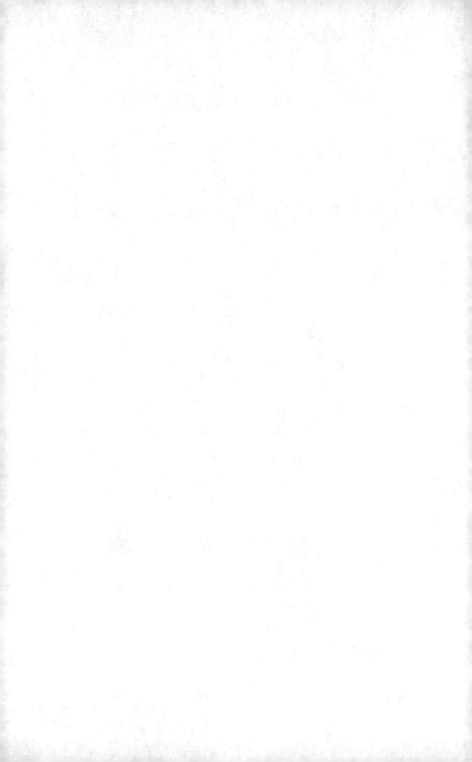

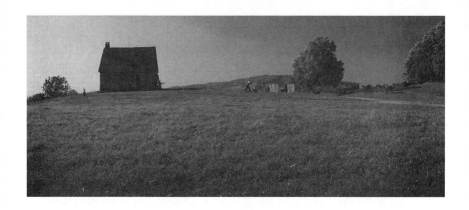

THE OPENING SEQUENCE OF this film is a masterpiece of rising tension, achieved through a simple combination of shots.

In most films, establishing shots are filmed at an angle, but this opening shot is shot flatly, directly from the side, to make it look almost like a storybook image.

This shows us the house, the man with the ax, and the laundry hanging up, the road to the side, as well as establishing that we are in the middle of the countryside. These images are all vital to the scene that follows.

Establishing shots should do more than show where the scene is about to take place. They set the mood, and show all the important details that will be needed later in the sequence.

The next shot of Denis Ménochet with the ax is shot from a low angle. This puts our focus on him, rather than the countryside and other surroundings (which are revealed later when the camera tilts down).

Importantly, the framing lets us see the log and the house, as in the establishing shot, making it clear that we're still in the same location.

Reveal your character by hiding some of the scene's details, but leave enough detail that we know where the character is situated.

We cut away from this shot to see a young women hanging up laundry, and when she hears a distant engine, she pulls the laundry aside to reveal the approaching Nazis. At this moment, the focus is pulled from the laundry to the distant Nazis in an instant.

When you move one object to reveal something else, it's a powerful reveal so long as the focus changes rapidly.

This is shocking because the domestic imagery is replaced with something frightening. The Nazis are distant and slow-moving, which shows that this is going to be a tense scene, rather than one filled with action.

A slowly approaching enemy tells the audience that the scene will be tense, and makes the enemy seem calm and powerful.

The next shot of Ménochet shows him reacting, and we see the ax hanging in the air, never completing its strike on the log. The ax shows up well against the sky because of the low angle.

To show a character's emotional reaction, make the character do something physical and visual.

Ménochet sits on the log and stares ahead. The house remains just in sight on the right of the frame, so we know exactly where

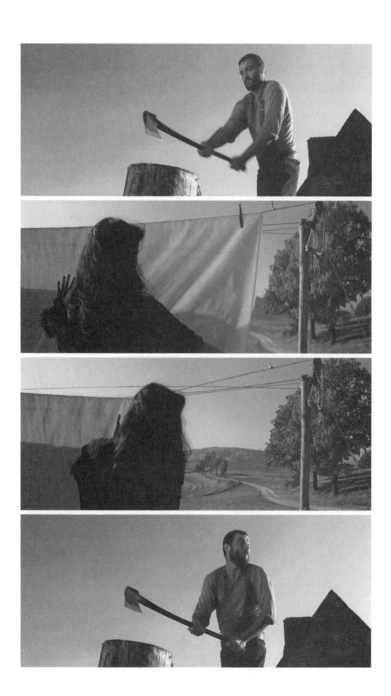

Ménochet is sitting, and that he's looking in the direction of the Nazis. He is apparently calm. This contrasts with the young woman in the background who runs frantically to get water.

When you show two things at once, make the foreground contrast with the background, to show what's really going on within the character.

We now see the first real close-up of Ménochet. At first he looks simply worried, but then presses the handkerchief to his face. The handkerchief is clearly significant to him. Moments like this may be scripted, but if not, try to find ways of showing your character doing something other than merely looking past the camera. A brief close-up can make us care for a character, if we sense that character misses somebody they love, or fears for loved ones.

Even in close-ups, show your character doing something other than merely observing.

The reverse angle is an over-the-shoulder shot, which connects everything together. We see Ménochet, the domestic location, and the approaching Nazis, who still seem to be moving extremely slowly.

Use a shot that shows your character and the approaching problem in the same frame, to connect them and raise tension.

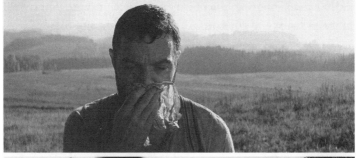

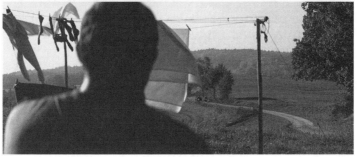

The camera now tilts down, as Ménochet walks toward the house. The tilt reveals the house, the grass, and the distant hills. When setting up this shot, Tarantino framed precisely so that in one setup we could see Ménochet chopping, see the ax freeze in the air, and then with a tilt we see him head toward the house where the conflict will take place. Careful planning gave him several powerful images, with nothing more complicated than a camera sitting on a low tripod, tilting once.

Rather than shooting lots of coverage, design shots that reveal more as the scene goes on, with simple pans and tilts.

Ménochet approaches a washbasin at the edge of the house, and then we cut to a close-up of him washing. This would have to be cheated, with Ménochet several feet away from the wall of the house to make room for the camera equipment. The important point is that while he is trying to clean himself, he remains a mess, in stark contrast to the pristine Nazi who appears in the next shot.

When your character is trying to remain cool, use visual cues and symbolism to show that calm is impossible.

The enemy has been coming for some time, but the wide shot is the first time we see Christoph Waltz. Notably, he is tiny in the frame, and walks with a smile and a spring in his step. This makes him appear far more frightening than if he loomed toward us in a menacing close-up. This shot is also functional in that it establishes that Waltz is accompanied by several armed guards.

You can make the enemy seem slow, small, even friendly, and you will build tension.

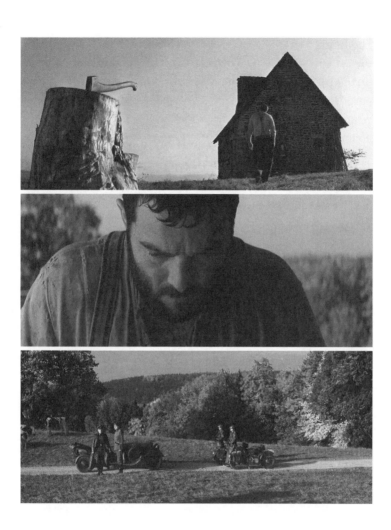

The characters finally meet, but first we get to see Waltz invading the domestic space. The camera is placed so that we see Waltz through the laundry, which makes it feel like he is striding purposefully into a private space. We glimpse the ax — a potential weapon — unused in the background, which implies there will be no immediate fight.

Tracking with a character gives us a chance to see the environment they are entering, but make sure you frame so that there are objects in front of and behind the actor.

At first the camera appears to be tracking directly alongside Waltz, but after a few moments you can tell that the track has been placed at an angle away from him. This means that as he approaches Ménochet, the camera moves farther away from the two of them. In one setup, Tarantino is able to shoot a medium close-up of the villain at the beginning of the shot, and ends the shot with a medium wide, showing both men. This is important, because we see the friendly body language of the enemy, and the fearful body language of the victim.

By angling your dolly track away from an actor's path, you can change the framing without ever cutting.

There is a brief close-up of their hands shaking, and then we cut to a shot of the two men almost silhouetted against the countryside, still shaking hands. The framing here is as simple and direct as possible, so that we are looking at nothing other than the two men and the way they relate to each other. Ménochet's reluctance to shake hands is obvious, and we see Waltz's disturbing grin for the first time.

When two characters meet for the first time, try to show them both in the same frame. Make it wide enough to see their body language, but close enough to make out their expressions.

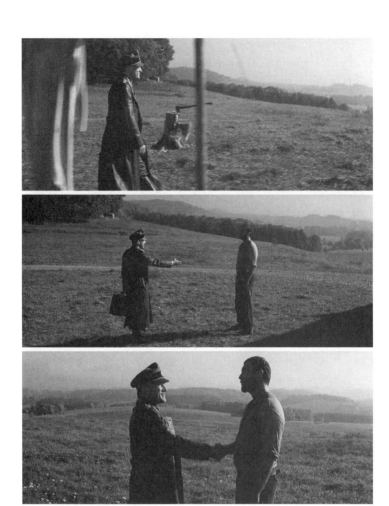

We see Waltz entering the house, but this shot also establishes that he's looking at the three daughters. Out the window we glimpse the troops, reminding us that there is danger outside.

Take the time to find framings that show who is in the scene, how they relate to each other, and what else is going on around them. This saves you shooting endless setups to cover everything.

The reverse shot shows the three daughters, framed centrally to emphasize their sense of being observed. Importantly, we glimpse a table to the right of screen, which sets up the geography of the scene.

When the main scene is about to take place in another part of the room, make sure we glimpse that part of the room in the opening shots.

We cut back to the first shot and the camera dollies a few feet to the left, as Waltz approaches the daughter on the left of frame. This reveals the window and the danger outside more clearly, and it shows that Ménochet is now cut off from his daughters. This subtle symbolism cranks up the tension.

We cut back to the reverse and see Waltz approaching the table ready to be seated. There is no need to shoot lots of coverage and angles. Simple imagery conveys exactly what is going on.

Let your actors move through the scene, and keep camera moves to a minimum to allow tension to escalate.

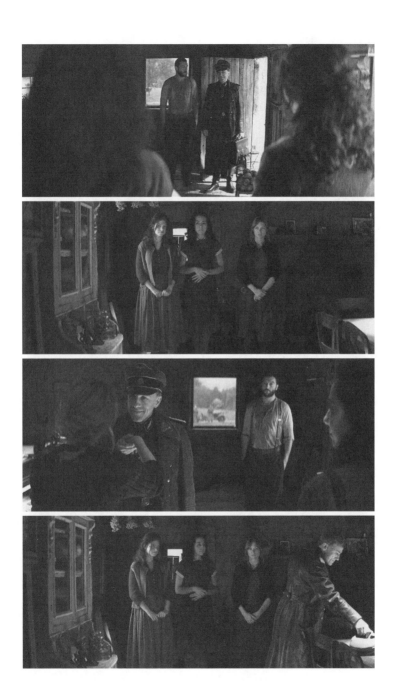

The tension continues to rise during a series of shots in which we see Waltz requesting a glass of milk, perhaps as a delaying tactic to watch the response of those around him. Most of the framings are simple and the only close-up we see during this scene is on Léa Seydoux, who is framed centrally, her eyes looking to the left of frame. This indicates that she is looking across at Ménochet, revealing her fear. If Waltz is trying to frighten them, this shows that it's working.

Use close-ups sparingly, only when you need to show a character's internal feelings. Central framing makes the shot more powerful.

We cut back to a wide of Ménochet, whose eyes are looking to the right of frame, showing he's made nervous eye contact with Seydoux. He then looks to the left of frame at Waltz. The camera is low now, at the same height as the seated Waltz, suggesting that the Nazi is in charge of the scene.

During moments of tension, put the camera at the head-height of the character who's controlling the situation to emphasize authority.

In a wider shot, Waltz leans in, urging Ménochet to lean in toward him. We can still see the daughters in the background and at the edge of frame. This proximity of characters makes it clear that the battle is going to be between these two. The daughters are sent outside.

Medium shots are an excellent way to connect two characters, while still showing the surrounding characters.

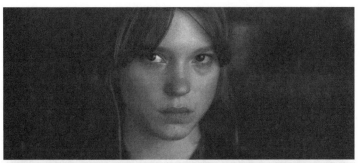

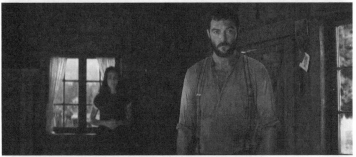

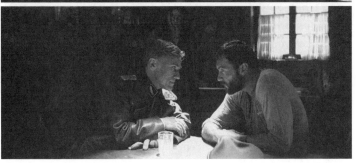

The main dialogue in the scene takes place in a seemingly conventional way, with two over-the-shoulder shots, and two medium shots. The composition of the first shot of Ménochet is interesting, because he is framed more centrally than in most films. This whole sequence has used central framing to imply a sense of being interrogated or observed, and that is preserved here.

When you've set a visual style for the scene, preserve that style even when you're focusing on the dialogue.

The over-the-shoulder shot of Waltz is an unusual choice because it is not a direct reverse. Normally, with the reverse angle you set the camera at the same distance, so that both actors appear the same size in the frame. Here, the camera is farther back, making Waltz seem small. By this point it's clear that his power is in his calculated calm, not his size, so letting him appear small makes him more frightening.

Even when you're shooting a straightforward conversation, consider how small changes can enhance the mood and tension of your scene.

The two close shots are fascinating because they have almost identical framing. Both actors are placed slightly to the right of frame. Normally, Ménochet would be on the right, and then when cutting to Waltz, he'd be on the left of frame. Instead, Tarantino has set it up so they both occupy the same space on the screen. The psychological effect of this is to make it seem as though Waltz has completely invaded Ménochet's space.

Symbolism helps to enhance the mood of a scene, even though the audience will not be aware of it consciously. Use framing to show one character taking another's place.

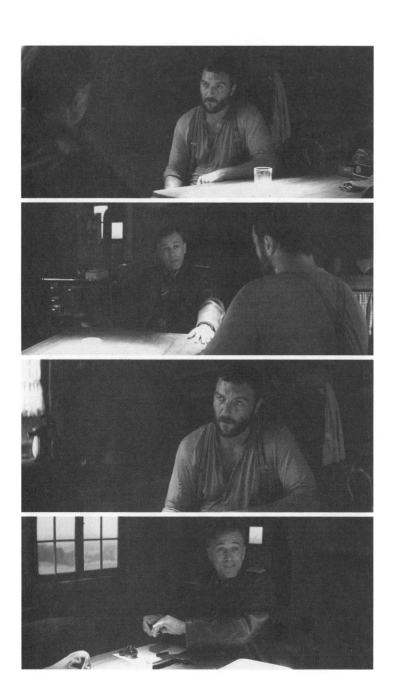

The next setup looks like a standard medium shot of the two characters talking to each other across a table. After a few moments, the camera moves to the left and circles around the back of Waltz until it ends up on the exact opposite side of the table. The characters have switched position in the frame.

This move creates the sensation that something else is going on, and that despite their stillness, tension is rising. No matter how mundane their conversation appears to be, the camera move shows that something is happening.

Before the tension reaches its climax, let the scene become still, but move the camera around the actors to show that the danger is increasing.

We jump cut to a close-up of Ménochet, from the same angle. There are several jump cuts in this opening sequence, and all work flawlessly, which means Tarantino must have insisted on exacting performances, with the actors re-creating physical movements perfectly. This usually means the jump cuts were planned.

If you want to jump cut, plan ahead and let your actors know they need to replicate their performance exactly.

The shot begins looking at Ménochet's back and, because we can't see what he's looking at, we expect another cut, or a move that will reveal something. To our surprise, the camera drops down toward the floor, toward his feet, below the floorboards, and to the climax of the scene. The camera doesn't show us what he's looking at, but far more importantly, it shows us what he's thinking about.

When you show an actor from behind it feels like something is being hidden. Whether you move down, up, or somewhere else, use this moment to show what the character is picturing and the buildup of tension is complete.

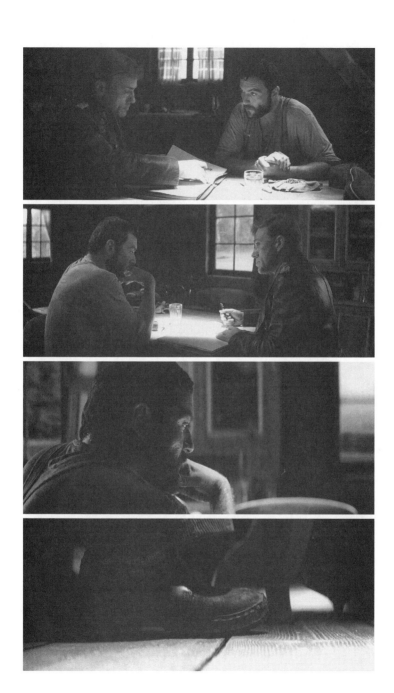

SUBTLE CONFLICT:
Jackie Brown

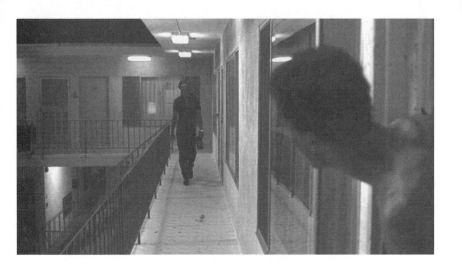

THROUGHOUT *JACKIE BROWN*, Tarantino gets his actors to stand facing each other to create a subtle, unnerving conflict. This approach means you can shoot long takes, where the pace is dictated by actor performance rather than by editing technique. It's ideal for establishing a growing conflict between two characters.

The danger with these face-to-face conversations is that watching two characters from the side can be frustrating. We don't get to see their expressions directly, and a long conversation can be visually dull. That's why this scene begins with Samuel L. Jackson walking in from the distance, with Chris Tucker sticking his head into frame on the right.

When you're going to shoot a conversation in profile, make sure you start the scene in a visually interesting way. Have one character appear in the distance and move forward while delivering dialogue.

Given the length of the upcoming conversation, it's important to keep the visual interest high. When the characters hug, they do so some distance from where the scene eventually takes place. Tucker heads away from the camera to meet Jackson partway.

If you're going to shoot a face-to-face conversation, let the actors meet somewhere away from the camera, before coming to a stop where the conversation takes place.

The actors then turn and walk toward the camera. Again their physical interaction here is strong, with large gestures, and Tucker leaning in to see Jackson's face. Without this level of energy it will look as though your actors are walking up to take their places in front of the camera and it will feel artificial. It's important to start the conversation while they are still on the move.

Keep as much physical movement going on as is plausible for your characters, and get the conversation started long before they come to rest in front of the camera.

At this point, the actors take their places where they will remain (almost exactly) for the rest of the scene. This is quite an unrealistic position for two people to assume, but it works because as they take their positions the conversation is moving at a great pace. We don't question why they're standing face to face outside the front door because we're listening to them interact.

Time the scene so that when your actors settle on their marks in front of the camera, they're in a strong interaction — either an argument or joke — to distract the audience from the artificial way they come to a stop.

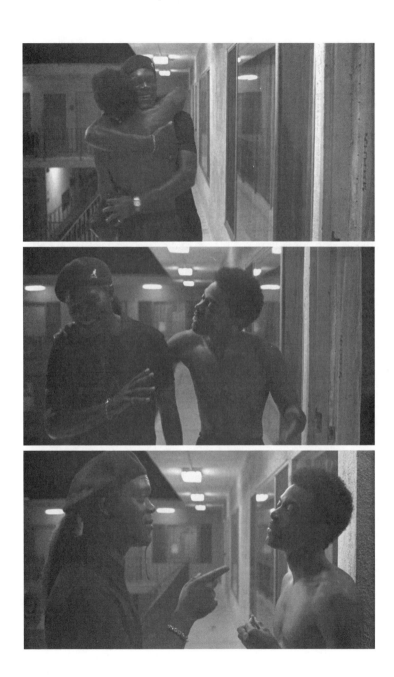

When a scene runs for over three and a half minutes without a cut, give your actors plenty to do other than talk to each other.

Tell your actors that you need visual interest, and they will come up with ways to move and interact that are in keeping with the characters. Here, Jackson puts his hand on Tucker's neck.

Get the actors to interact physically, and if you don't see enough of this in rehearsals, suggest specific moves and motions for them to use.

Give your actors an excuse to turn their heads toward camera. In the second frame, Tucker blows smoke, but rather than turning his head away from camera he turns it toward camera, to ensure we catch his expression.

Give the actors moments where they can turn toward camera, no matter how briefly.

You can also have one actor move away from the other. Chris Tucker backs off for a moment, which means we see his face and expression more clearly.

Keep the camera still, and let one actor move away from the basic setup, but return to it right away to maintain tension.

Jackson turns his face toward camera as he laughs, but it is a brief moment before eye contact is resumed. When the actors look at each other directly, you create the greatest sense of an underlying conflict.

For the majority of the scene, get the actors to make eye contact. It is this connection that makes the audience pick up the subtle dangers within the dialogue.

ANTICIPATION:
Inglourious Basterds

THE SCENE THAT TAKES PLACE in the basement bar is one of Tarantino's greatest moments, but it would not have worked as well without a good buildup in the scene that comes just before.

In this scene the characters talk through their plan. This serves the needs of the plot, but visually it sets up a sense of fear. The characters are focused on the basement bar they fear, and they appear to be confined in a tight space.

The scene begins with a simple establishing shot on the basement bar, which we don't see again during the entire scene, but we see the characters watching the basement.

When you want to make a location seem important or frightening, show it briefly, before showing the actors observing it from a distance.

The framing ensures that we see the window as clearly as we see the actors. They are looking down at the basement bar, so we need to see their tense body language, as they look down, but we also need to see the window clearly.

Good shots don't just show the actors, but show them at a specific time, in a specific place and a specific situation. The opening shot of a scene should do this most clearly.

Once the window has been established, the camera pans slightly to the right, as Gedeon Burkhard moves into the shot and Brad Pitt turns to talk to him. Importantly, Michael Fassbender continues to look out the window. This keeps our awareness on the unseen basement, even as the characters converse.

You can reveal your location with the smallest pan. This works best when another character moves into the scene at the same time.

The next shot is a jump cut. Shot from almost the same place, but with a longer lens, this requires you to get the actors to play each take with identical body language and timing. By staying low and near the window, and jump-cutting, rather than cutting to a different angle, you will leave the audience feeling as confined and covert as the characters.

Jump cuts enable you to get closer to actors, to see their expressions more clearly. As a rule, you cut on a turn of the head, or another body motion that hides the cut.

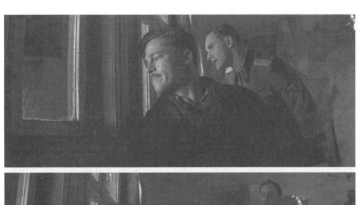

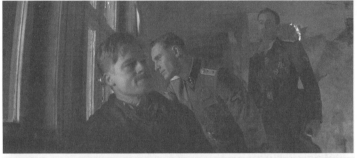

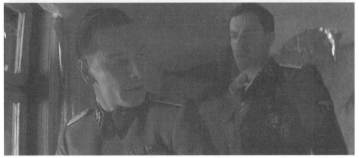

There's a brief interlude where Fassbender walks out of the scene to talk to another character. Importantly, when he returns, the shot looks almost the same as before, maintaining the sense of confinement.

Once you've established a scene, keep it tense by shooting it in the same way for as much of the scene as possible.

Once again Tarantino uses jump cuts in this scene. The first comes as Fassbender kneels down to join the others. The wider shot of him approaching establishes that we're in the same place and then we jump-cut closer to watch the dialogue take place.

Why jump-cut when you could shoot from two different angles? By shooting from a near-identical position, you establish a strong sense of place. By repeatedly shooting from the same angle, you lock this sense of place into the audience's mind. It's far more intense and claustrophobic than if the room were shot from all the standard angles.

Shoot from one position for most of the scene, using jump cuts to get your close-ups, and you create a stillness and tension that would be destroyed by extensive coverage or camera moves.

To add visual interest, Pitt's character shuffles around, blows his nose, and eventually turns to speak directly to Fassbender. This prevents the scene from becoming too dull, which could make the audience drift off and stop listening to the dialogue.

When shooting tense or claustrophobic scenes, give the actors some room to move and interact, to prevent the scene from becoming too frozen.

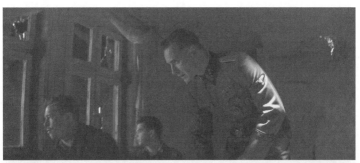

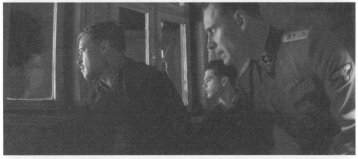

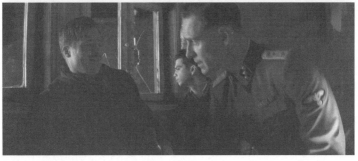

After another jump cut to the wider lens, the camera pans with Fassbender as he walks off to the right. Apart from the interlude where he left the scene briefly, this entire sequence has been shot with two camera setups and one simple pan. The camera is low throughout, which means we are on a level with the actors when crouched, but looking up at them when they stand. This gives the scene a lot of visual richness without any complex moves, and without shooting a lot of coverage.

Try to get your actors on different levels as they move through the scene, but keep the camera on one level to increase the visual impact of the shots.

All the rules that have been established for this scene are now broken, as Tarantino shoots a reverse of a character down on the bed. Notably, his feet are in shot at several other points before this moment, so we have an awareness of him being present in that part of the room. Also, by having his feet so close to camera the sense of a confined space is again increased.

If you're going to change angles abruptly, make sure the person you're looking at has already been glimpsed in other shots.

This scene is also notable for using a form of visual contradiction. The actors hide behind the window frames, as though being seen would be a catastrophe, but then stand up and pace around casually where they can be seen. This generates unease in the audience, without appearing implausible.

Find subtle ways to add visual contradictions such as this and your scenes will feel even more tense, without the audience knowing exactly why they feel uneasy.

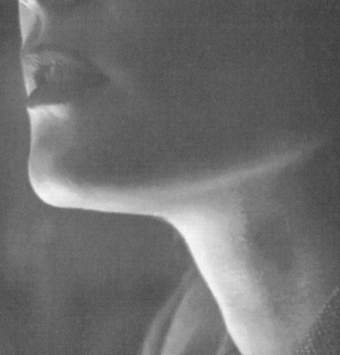

UNBEARABLE TENSION:
Inglourious Basterds

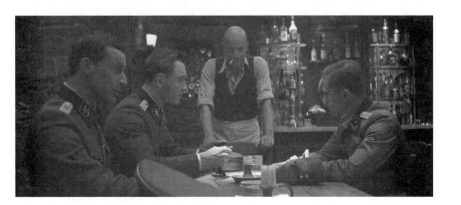

How do you make a twenty-five-minute-long scene tense and fascinating? This scene could be described as Tarantino's masterpiece, but it relies on much more than good writing and acting.

Throughout this scene there is a sense of visual invasion or intrusion. Symbolically this reflects World War II, and it also reflects the mission of the main characters. In terms of filmmaking, it is a unique way of creating a sustained sense of tension.

Throughout the scene, characters continually intrude on each other's space to ramp up the tension without any change of pace.

In the shot above, the group of disguised solders are settling in, when the barman takes his place between them. By itself, this means nothing, but when these intrusions are repeated they create an unbearable tension.

Visual interruptions, where unwanted characters invade the space of your main characters, help create tension and sustain long scenes.

There are few camera moves in this scene, with most of the work being done with pans and cuts. When a dolly move is used, it is slow and has a purpose.

Starting close on Fassbender and Diane Kruger, we pull back slowly to show that Gedeon Burkhard is also taking part in the conversation. This gives us the slightly cozy feeling that all is well and the secret meeting is going ahead as planned.

A slow reverse dolly, to reveal the presence of characters, can establish that a group has gathered together, perhaps for a covert purpose.

As soon as this feeling is established we get another visual intrusion. The barman comes over and pours a drink. The effect is subtle, so it needs to occur at a point when particularly secretive dialogue is taking place. To emphasize this, Fassbender leans away from the barman more than is necessary, and Kruger lights a cigarette.

Visual interruptions can be quite subtle, but early on in the scene you should time them to coincide with moments of tension or secrecy in the dialogue.

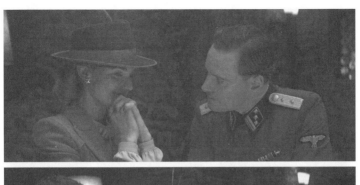

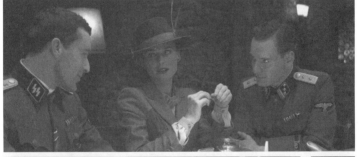

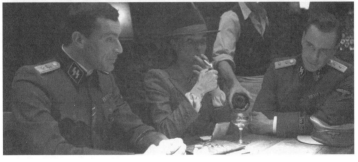

Later in the scene, timing again helps with the effect. The group is arranged together in a single frame, looking relaxed, and Kruger is about to reveal vital information. At this point there is a series of rapid cuts.

The first is to a shot from behind Kruger and Fassbender, with the focus on the approaching German guard. Not only does he put our heroes out of focus as he interrupts, he also walks across the frame and eventually stands so that he is between them. Visually, he takes over the scene.

When somebody interrupts a scene make it as visual as you can, by putting other characters out of focus, or moving directly between them.

The next cut is a profile of Kruger, and although brief, this shows that she is suddenly isolated. She's still in a crowded room, but the camera is positioned in such a way that we can see nobody else.

If you want to show a character's fear, especially when that fear shouldn't be evident to other characters in the scene, you can show the lead character alone in the frame.

In the next shot the camera is low and the framing has pushed Fassbender right out of shot. Even Til Schweiger, who is normally a large presence in the film, seems small, because the camera is looking up at the German guard. Kruger is out of focus on the right, barely in shot. Everything about this framing suggests that this guard, even though he is drunk and weak-looking, has broken this group apart.

Shoot from a low angle to make an interrupting character appear more domineering. Increase the tension by making the other characters appear small and separated.

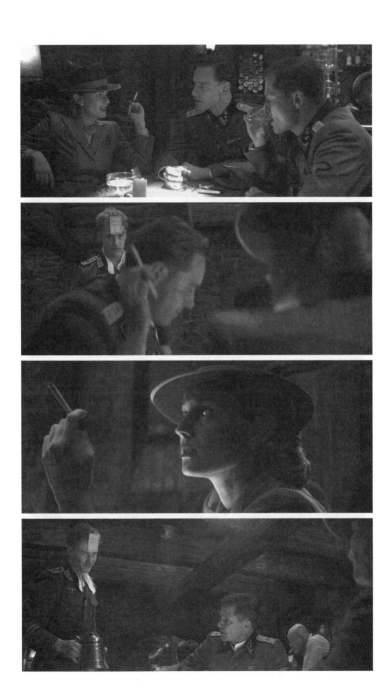

As an argument breaks out, there is a slow dolly back from the crowd, and this is the first time we have seen all the characters at once. A wide shot of the entire scene gives us the sense that something is about to happen, and we hear an off-screen voice. We then cut to see August Diehl. It's unclear at this point exactly where Diehl is seated, but this interruption works because of the disarming confusion.

Some visual confusion can work, when a new and threatening character appears. We don't need to know where he is, only that he has chosen to become involved.

He stands slowly and the camera dollies to the right, until the wide shot we saw from earlier comes into view behind him, albeit out of focus. By having him walk into a framing we have already seen, he is interrupting the flow of the scene and taking over. Tarantino actually has him pause and fiddle with the gramophone for a moment, as though to let this visual impact sink in, and also to make us wait to see what happens just a little longer.

Vitally, there is no cut at this point. Diehl turns his back on the camera and walks into the scene. If we'd simply cut to a shot of him entering the crowded room, he may have seemed over-whelmed. The framing used ensures that Diehl is the strongest presence in this part of the scene.

A powerful and frightening character appears more frightening when first shown alone, especially if the character then moves into a framing we have already seen.

Study this scene in its impressive entirety to see countless examples of physical, visual, and symbolic interruption that keep the tension high throughout.

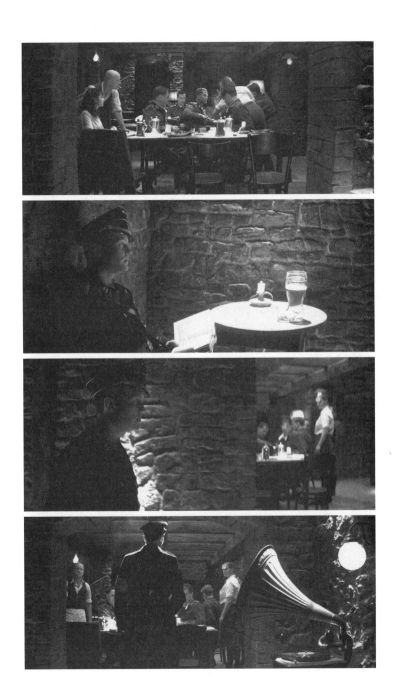

MINIMAL CUTS:
Django Unchained

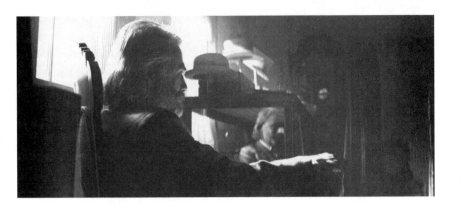

I N A FILM THAT USES a lot of fast cutting during action scenes, you might want to slow things down when there's a more conversational moment.

This scene from *Django Unchained* keeps the camera in the same place with only minimal movements, and one cut, but we get to see everything we need to see. Christoph Waltz is positioned so that we can take in his body language, and we see his reflection in the glass. We are able to see both characters and their interaction without endlessly cutting between the two of them.

Careful use of reflections enables you to show both characters at once, but the reflected actor may need to play the character a little larger than usual for this to show clearly.

In the opening frame, the focus is on Waltz in the foreground, and we listen to him, while watching his body language and hand movements. He is also turned slightly toward camera, so we can glimpse the edge of any facial expressions. Jamie Foxx moves about on the right of frame, almost in the shadows and not yet a major part of the scene.

Keep the focus on the foreground actor, but encourage acting through body language.

When Foxx stands, he turns and faces the camera and the focus shifts to him. At the same time Waltz turns to face Foxx more directly, so that we see his reflection clearly.

When the actor in the background turns toward camera, the foreground body language becomes less important than the reflected expression.

Foxx moves out of the frame to the right and we cut to a shot of him standing by the cupboard. The camera remains low, in keeping with the other shot. The scene is about one character watching and mentoring the other, so the point of view should be kept roughly the same.

If you cut to a medium close-up, keep the camera at the same height to give the scene consistency.

When Foxx returns to the original framing, the focus is once again on him. He's looking directly at Waltz, but his body is facing the opposite direction as before. Directing your actors to make small changes such as this can have a large effect on the scene. Rather than seeing him retake his position and continue a conversation, this shows that there's been a moment of change or revelation.

Directing your actor's body language within the scene can be as important as the framing.

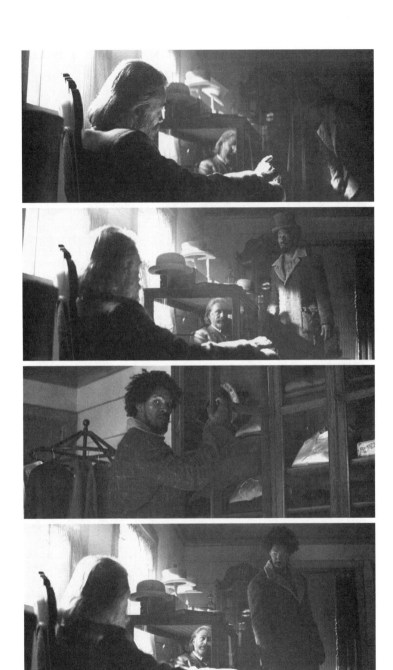

IMPENDING VIOLENCE:
Django Unchained

WHEN THE VIEWER SENSES that a dramatic or violent scene is about to take place, you can build that sense of tension. You are not creating tension for the sake of tension, but to make the violent scene have more impact.

It is a hallmark of Tarantino's films that violence can happen suddenly and off screen, or after a long buildup with great visual detail. Both effects work but in this scene we sense from the script that Jamie Foxx's character is ready for action. The framing reflects this by ensuring we see his expression in close-up but because we see him from the side we know he's on a mission to somewhere else.

When a character is about to move into an action scene, have that character look into the distance and approach the action deliberately.

As Foxx moves off we jump-cut to a wider shot, and this enables the camera to pan with Foxx as he moves off. In the close-up he looked relatively safe, because only he was in focus, and the rest of the environment was blurred. Now, as he walks off, everything else falls into focus. Despite his determined walk, he is quickly swallowed by the unfamiliar environment and made to appear small.

When you want your character to appear overwhelmed by what's ahead, use a wide lens and pan to reveal the territory your character is heading into.

The next shot is of Kerry Washington being dragged across the frame. She is close to the camera at the start but during this brief shot she is pulled away from the camera toward the tree where she will be tied up. A moment later we see M. C. Gainey pacing back and forth cracking a whip. In moments, Tarantino has shown us exactly what's at stake. If Foxx doesn't make it to the scene quickly, Washington will get whipped, and if he does make it in time, there will be a confrontation with at least two mad men.

When you've suggested that violence is coming, show the victim and the villain in quick succession.

Gainey is filmed from below to make him appear more threatening and the camera pans with him as he moves. This makes him seem to be more in control than if the camera remained still and he moved within the confines of the frame. The camera tracks him like an animal and this gives the impression that he is a vicious predator.

Shoot from a low angle, so the villain appears taller and more imposing, and so there are few visual distractions in the background. This creates a greater sense of menace.

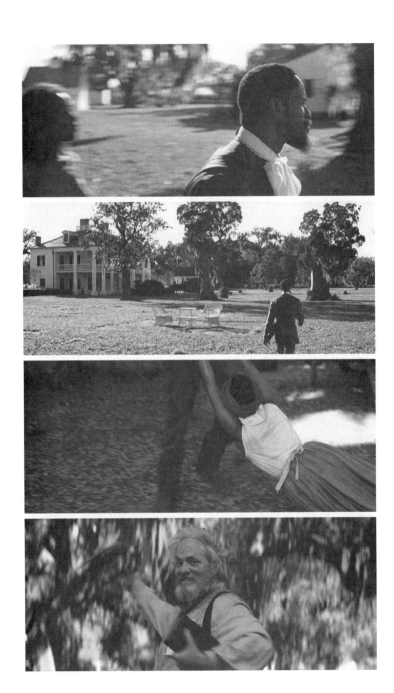

To ramp up the tension we see a close-up of Washington struggling with an unseen assailant, and the camera is handheld to add a sense of panic. This contrasts with the next shot, which is shot with an extremely short lens and a motionless camera, with Foxx in the far distance. He appears tiny in the frame, which gives us the sense that he is barely moving and won't get there in time.

You can increase the sense of tension in the audience when you contrast a close, fast shot with a wide, slow shot.

Tarantino releases the tension slightly in the next shot, by dollying alongside Foxx as he strides forward, which makes it feel as though some progress is being made. Foxx remains on the right side of the frame, though, so we don't feel he's advancing as fast as he could. In the background we see women on swings, and people relaxing. This contrast again helps to increase our unease.

Tension can work best if you give the audience some hope, so ease the tension slightly by shooting a fast dolly from the side to show the character's pace.

There's a brief cutaway to Foxx's feet striding through the grass, then the camera is placed directly in front of Foxx and it dollies backward at his pace. This is a moment of change in the dynamic. By placing him centrally in the frame, and striding purposefully, it feels as though he is taking control of the situation. If the camera was stationary, it would feel like he was still in desperate pursuit, but the backward dolly makes it feel like he's driving the pace.

Frame your actor centrally and dolly backward, to give the impression that there's more hope and that your character is about to take action.

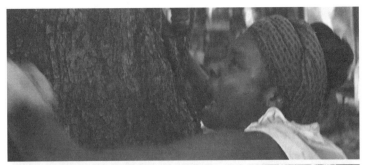

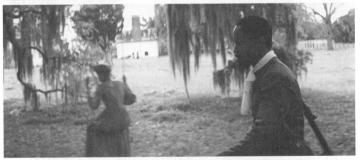

Having given the audience some hope and making it look as though things could work out, it's important to raise the tension levels again. It's this play of hope and fear that creates the anticipation that puts people on the edge of their seats.

The opening frame has Gainey in the distance with his whip. Washington is close to the camera but she is framed so that we can't see her clearly and she is out of focus, so that Gainey dominates the frame. As he approaches, he remains quite small in the frame but appears to be a threatening presence because he has closed in on her without resistance.

Show your villain and victim in the same frame, but give the villain more presence by obscuring the victim slightly.

The audience should feel that all is lost, so rather than cutting back to Foxx, it's important to see the expression on the other characters' faces. The close-up of Washington gives us a moment to see her predicament, framed so we can see her fear, her naked back, and that her hands are tied. The cut to Gainey shows that he remains in control as the camera is low and looking up at him.

Your close-ups can and should reveal important plot details, as well as showing the actor's expression.

The climax of this scene happens in just a few seconds, and Tarantino plays a visual trick, because Foxx arrives on the scene when we think he's still a good distance from the action.

The trick is to follow Foxx in as he strides toward the barn, but then have him curve rapidly around to the left with the camera following. He stops and the camera stops, with Gainey and Washington framed in the far background. His walk toward the barn and his sudden arc around don't make complete logical sense but it works visually. For a moment it feels like we're still a long way from the scene of the action but then, in one quick turn, we're right there.

You need to keep surprising the audience. One way is to make them think the tension is going to continue, and then end the tension abruptly with a quick camera move.

At this moment, Gainey and Foxx come face to face but, rather than having Gainey look around suddenly, he turns around slowly. Initially, the focus is on Washington tied to the tree and only as Gainey turns to face the cameras does he come into focus. This slow turn and shift of focus shows that this is more than a mere annoyance to Gainey and that he is ready to do battle.

When you want to show impending violence between two characters, let the villain move slowly to increase our sense of dread.

DELIBERATE ANTICLIMAX:

Kill Bill: Vol. 1

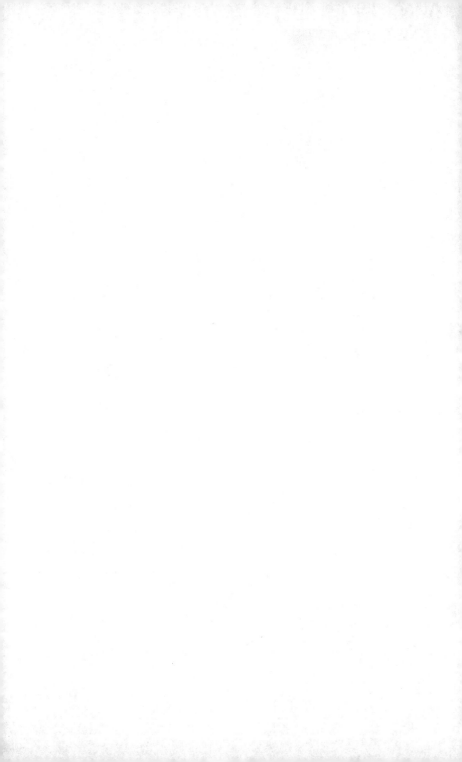

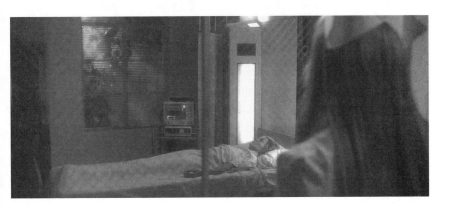

SOME OF THE BEST SCENES surprise us, but sometimes we know that there's going to be an anticlimax of sorts. At this point in the film, Daryl Hannah has been sent to kill Uma Thurman. We know it's unlikely to work, because the film's hero can't die when there's still a couple of hours to go. Keeping a scene like this tense and interesting requires the use of clever timing, slight humor, and building a sense of menace for future scenes.

The opening frame shows Thurman unconscious in bed, vulnerable and being observed by Hannah. Importantly, there is a barrier between the two of them. The out-of-focus window grill serves to show that Hannah hasn't simply waltzed in and performed a quick assassination. It indicates there's going to be more to this scene. Subconscious tricks like this might seem subtle or theoretical, but have a huge effect on how well the scene works.

When you have a potential moment of action that will ultimately be defused, put a physical barrier in the way of the characters to show that things aren't going to be simple.

To make Thurman seem at risk we need to see Hannah break into her space. The next shot shows Hannah behind the window grill, with her assassination equipment clearly on show. She then steps to her right, out of the frame, to come through the door. Having her exit the frame completely is more powerful than cutting as she's on the move. It shows that she's left the space where she was separated from Thurman and is breaking into her space.

If you want to show a character decisively moving from one place to another, let the character walk out of the frame without panning to follow or cutting to another shot until the frame is empty.

To show Hannah intrude into the room, the shot begins under the bed. We can only see Hannah's feet and then the camera rises up to the final framing without a cut. Starting under the bed is more visually interesting than cutting to a simple shot of the door but also makes the entry seem sneakier and more covert. Stopping the camera at the level of the bed means we feel Hannah's threatening presence because the camera is tilted up at her.

In scenes where we know roughly what's expected to happen, keep the visual interest high by cutting to unusual framings at the beginning of the next shot.

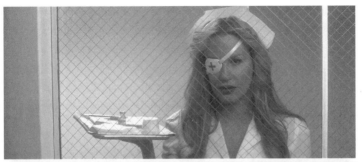

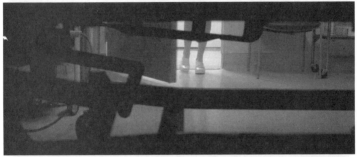

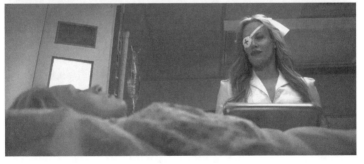

This scene could work without a close-up on Hannah but because Tarantino wants to show her finger resting over Thurman's mouth — to see if she's breathing — that changes the balance of the scene. Although Thurman is asleep and shot in profile, the shot of her sleeping is a close-up. For this reason, we first see the close-up of Hannah to ensure that she remains the dominant presence in the scene.

When you want one character to appear vulnerable, if you shoot that character in close-up, make sure you shoot a close-up of the villain to help balance the scene.

As Hannah continues her dialogue, the framing is identical to before but she is directed to move the hypodermic syringe around at a level where it can be seen clearly. This sort of blocking can often seem unnatural to actors so you need to reassure them that, with your particular framing, it's vital that we see the threat visibly.

To ensure we're in no doubt we cut to a close-up of the needle being inserted into the tubing. Tarantino uses a lot of close-ups of hands and objects to emphasize their importance in the scene. Seeing the needle being inserted into the tubing indicates that the assassination is about to happen, against our expectation, and is a key plot point.

If there's an important physical detail in your scene, shoot an extreme close-up. This can help with editing but also ensures the audience isn't left guessing about what's going on.

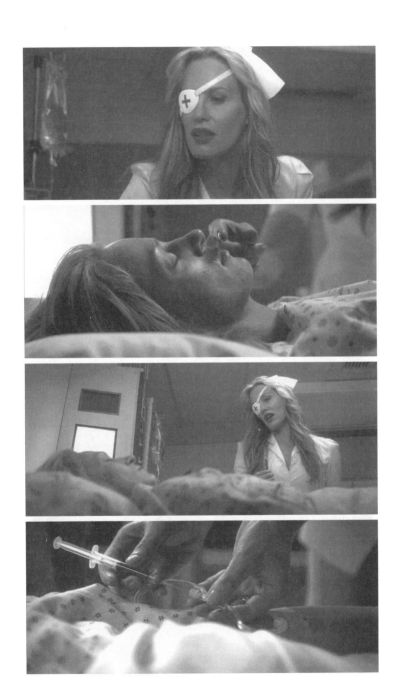

Tarantino lets Hannah answer the phone with the same framing as before to emphasize that this phone call is an interruption. She has not moved from the place where she seemed powerful but, now, rather than being armed and dangerous, she's having to take a call.

To interrupt a moment of drama, keep the same framing you've used so we can see the character being disturbed in a framing that is now familiar. This lets us sense the actor's reaction to the interruption.

Rather than showing us Bill, we cut to see his hand resting on his sword. Deliberately withholding the face of a character can be a useful way to make the audience anticipate the character's appearance, or it can feel like a gimmick, but it does ensure that dialogue is heard clearly. Shots like this should reveal several things about the character. We can see that Bill is sitting in a relaxed posture, he's holding a weapon, and he appears to be wealthy.

When you reveal a character gradually, make sure that each close-up reveals significant details about the character.

The next cut puts Hannah at the window and the camera on the opposite side of the bed. This indicates that a subtle power imbalance has come into play. She's been moved from her position of power. Hannah is the one in focus, but she's small in the frame. To emphasize Thurman's growing power even more, we close in on her, putting her in focus and making her appear larger in the frame. Despite Hannah's ongoing rant, the tiny details of Thurman's flickering eyelids catch our attention.

When a character is being disempowered, make the actor appear out of focus or small in the frame.

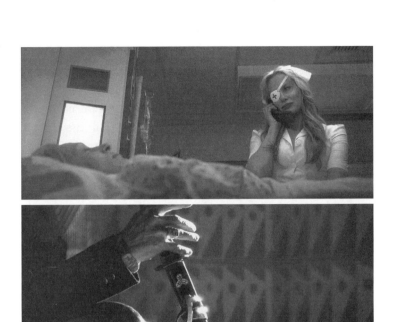

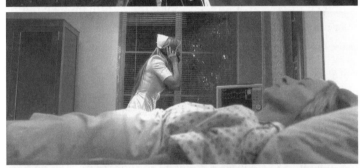

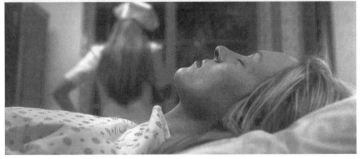

Having broken the tension, it's important to lift it once more. The purpose of this scene is to foreshadow a fight to come but it's important that the audience has a moment of doubt and the sense that something unexpected might happen. In the first frame, we see Hannah alone in the frame with her back to the camera. This is a classic horror movie shot that makes audiences expect a sudden surprise.

In scenes where the action dies out, you can use camera technique to raise audience tension and hold their interest. A shot that makes us wonder what a character is thinking, and what the other is doing, is a perfect example.

There is a "horror movie moment" but with the tension raised we now turn to see Thurman on the bed, looking extremely vulnerable, and then Hannah moves into the frame. It's essential that we see Thurman alone for a moment, to create the moment of fear as Hannah steps into frame.

If one character is in danger, make the villain appear in the frame to startle the audience, to remind them that the villain is dangerous, even if the real danger is yet to come.

With the assassination called off, the scene closes with a close-up of Hannah, shot from below. Normally when you shoot from below, it imbues the character with a sense of power, but, given that she is almost looking into camera, this shot is virtually from Thurman's point of view. This makes Hannah seem as though she's the one on the defensive. Although the shot creates foreboding, as the threatening dialogue is spoken, the angle makes the anticlimactic end of the scene feel like a payoff, because it seems as though the hero is about to take back control.

When a villain falters, you can shoot from below but shoot from the other character's point of view and have the villain look almost directly into the camera. This helps us see the villain's vulnerability or fear.

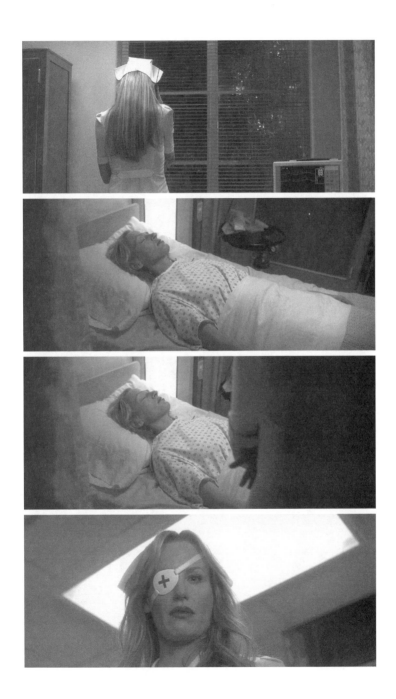

BREAKING NORMALITY:

Pulp Fiction

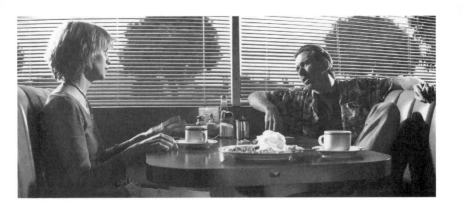

THE OPENING TO *Pulp Fiction* is memorable because Tarantino makes the planning of a robbery look as normal as eating breakfast. The scene is over four minutes long, and dialogue heavy, so he shot a lot of coverage.

Shooting from so many angles makes editing easier, and also gives the actors the opportunity to explore different performances. The opening shot, however, is all about setting up normality before breaking it. When the violence eventually erupts we return to a framing almost exactly the same as this, so it's important to establish this as the ordinary world of the scene where everybody appears relaxed.

When shooting a long conversation, your master shot can be as simple as a two-shot of the characters talking, almost in profile.

After the characters have talked for some time, cutting to close-ups could feel too abrupt, so Tarantino builds in some motion by having the waitress enter the frame at the left and a fraction of a second after we've seen her enter the frame we cut to a close-up. Having shown us a close-up of a character other than the main characters, it now feels less jarring when we cut back to close-ups of the main characters.

In long dialogue scenes let other characters intrude to help you cut to the close-ups.

The first close-up shows the waitress pouring the coffee, which is more effective than if she was absent from the frame. Her presence here makes the cuts flow at a point where they might otherwise feel too abrupt. We now see Amanda Plummer in a close shot and cutting in this tight on her does not feel awkward.

If a third party enters the scene, it helps if we can see that actor in the scene when we cut back to the main characters.

Tarantino can now cut back to a wider over-the-shoulder shot of Tim Roth without it feeling clumsy. If the scene had simply been shot wide, then with over-the-shoulder shots, and then close-ups, it would have either felt too conventional or too long. Once you've gone in close, you can move back out again to wider shots, looking more directly into the main characters' eyes. The closer we are to looking directly into their eyes, the more we sense their emotions.

When shooting coverage of a scene like this, don't be afraid to move out to wide shots once you've gone in close.

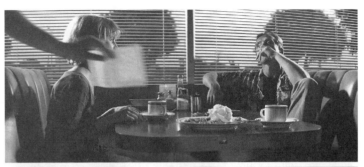

Having established this pattern Tarantino can now cut freely between the different setups, including this close-up on Roth that has such a tight eyeline it almost feels like it's from the point of view of Plummer. The next shot is a direct over-the-shoulder shot from behind Roth and we don't cut to this until Plummer has relaxed on the table. It would have been possible to shoot this entire scene with the characters never moving, but Roth shifts around and Plummer almost lies down on the table. This keeps the scene visually bright but you should only use these movements if they reflect the characters and their current dialogue.

Encourage your actors to move in the frame, to keep our interest, but ensure your camera is set up to frame them properly when these movements take place.

While Plummer is still prone, there is the only camera move of the entire sequence as we push forward toward Roth so that he is alone in the frame. This separates the characters and shows a slight friction building between them. For the audience, this creates the sense that something unpleasant may be about to happen.

When two characters are locked in conversation, move your camera so that only one is framed and the audience will feel a sense of foreboding.

With the mild sense of foreboding in place, the next shot of Plummer works by showing her in isolation. Throughout the scene she's appeared to be connected to Roth but now her eyes are closed and she's in a frame all by herself. This shows her in isolation. When watching this scene, the characters seem perfectly in synch. The subtle unease being shown here foreshadows the climax of the scene, which isn't revealed until the final minutes of the film.

When something's going to go wrong later on, you can hint at it by using these careful shot choices.

When Plummer sits back up we cut to yet another setup. It's another over-the-shoulder shot from farther back, showing that Tarantino must have shot this scene many, many times from many angles.

In a lengthy dialogue scene, be prepared to get lots of coverage but make sure your actors see it as an opportunity to explore the characters rather than merely doing the same thing many times.

The close-up of the gun going onto the table is functional, in that it shows us that battle is about to commence, but it works more effectively than seeing this from a wide shot. By showing the gun so directly, it's almost like promising the audience some action. The close-up of the kiss works because it's unexpected and also a complete contrast to the wide shot that will follow.

When you're about to cut to a wide shot of an action sequence, a series of close-ups can help build the anticipation.

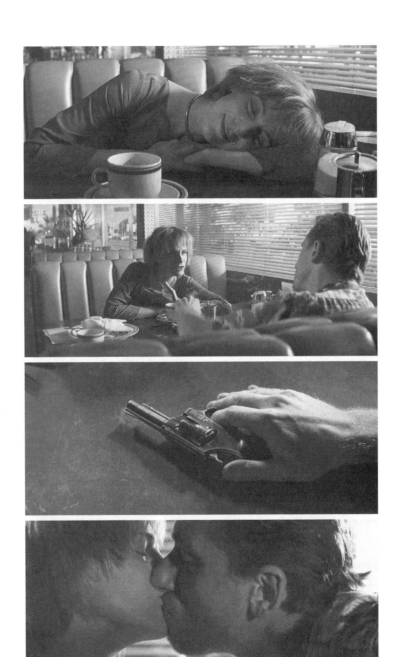

The opening framing is similar to the beginning of the scene, but the camera has been pulled back to enable us to see the action that follows. Getting this angle works because it returns us to the apparent normality of a breakfast scene, which we know is about to be ravaged by violence. As Roth stands, the camera tilts up with him, so that the familiar setting vanishes completely. Normality has gone and the action is underway.

Establish the scene as you did at the beginning, then use a camera move to hide the familiar scene we've been watching for four minutes. This is a powerful way to get an action sequence moving.

In most films, there would be a cut to the other diners and we'd watch them reacting to the robbery. Tarantino is hiding a secret from the audience at this point and doesn't want to show who else is in the room but, even if that wasn't the case, this technique is probably more dramatic. We hear people scrambling and panicking but we stay focused on Plummer as she moves forward into the frame mirroring Roth perfectly.

There are times when it's best to show your main characters, and let us sense what's going on around them.

The final frame has both characters swing their guns to frame-right at the same time. This puts Plummer in the absolute center of the frame, so that we can see the wild and extreme delivery of her lines.

If you choreograph "cool" moves, ensure they are used to place your actors where we can best see their performance.

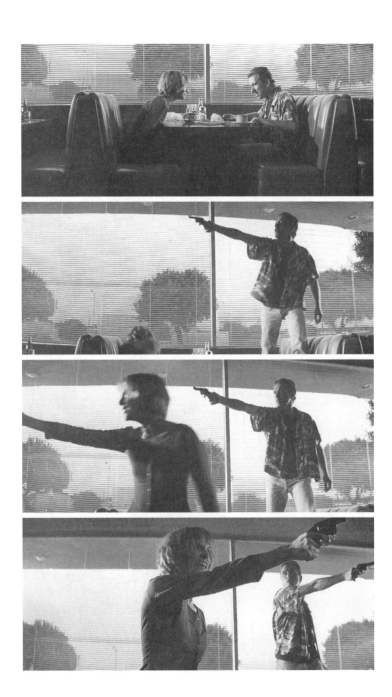

CONTROLLING SPACE:

Pulp Fiction

WHEN CHARACTERS MOVE from one space to another, you're faced with a storytelling challenge. This is especially true when there are multiple characters in the scene. If you handle the transition from one room to another clumsily, the audience becomes confused and loses track of dialogue and story.

This scene is one of Tarantino's most legendary and yet the setups are extremely simple, with the emphasis on clear storytelling. The opening frame shows us that Samuel L. Jackson and John Travolta are about to enter the door. This could have been shot from the side or above, but by making the door the central visual element we know that the next part of the story is going to happen in that room.

When your characters are about to enter a new space, let us see the transition point — usually a door — as clearly as possible.

To clarify that we're going through the door, Tarantino uses a trademark close-up of the lock being turned. It doesn't matter that we haven't seen who's behind the door or whose hand is unlocking the door.

Extreme close-ups are particularly useful when you're trying to show that something is about to change.

This brief point-of-view shot shows us several vital details. In this brief glimpse we see a nervous Phil LaMarr and catch a glimpse of the room we're about to enter, as well as another character reclined on a sofa. We can then cut back to a shot of Travolta and Jackson entering the room. We've been given a quick look at the space they are entering, so now we get to focus on the more important story point, which is their attitude as they enter the room.

At the beginning of this two-shot, LaMarr is on the right of frame, with both characters watching him move out to the right. This connects the shot to the previous shot. Without seeing him in the frame, the shots would feel disconnected. We then get to see Travolta and Jackson observe the room for a moment before Travolta crosses the threshold.

The point of this series of shots is to establish that there is a threshold and that it is being breached with calm and menacing deliberation.

When you shoot a transition like this, ensure that we glimpse the room where the scene will take place, then return to a shot of the main characters to show that they are in control.

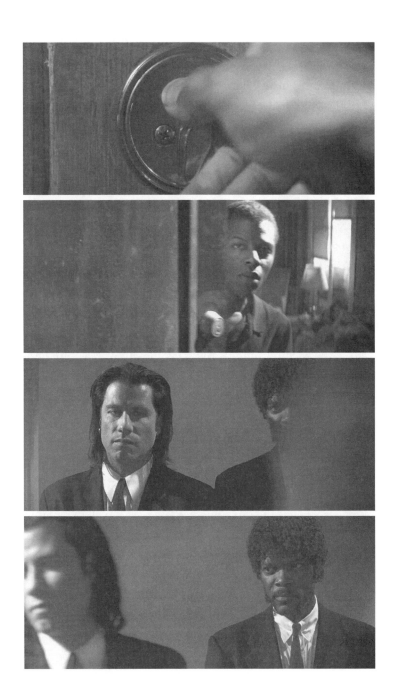

When you show a room for the first time, it's important to establish where all the main players in the scene are situated. Usually this is done with a wide master shot, and Tarantino does give us that. First, though, he lets us see the scene through the open door.

The initial effect is to make Frank Whaley appear small in the frame, overshadowed by the hulking silhouettes of Jackson and Travolta as they move across to the right of frame. We also glimpse Burr Steers reclined on the couch, clearly showing fear. The second effect is that the door slams toward us, as though to signify that not only has the threshold been crossed, but those characters now own that space.

Staying outside the scene for a moment can cement the impression of the main characters invading the space where the scene will take place.

When we cut to the master, Tarantino positions the actors so that we see the relationships clearly: Travlota and LaMarr are both standing, but LaMarr is backed against a wall, side on, making him appear nervous. Jackson's ownership of the scene is made concrete as he crosses to the exact center of the frame, while the other characters remain low and motionless.

This framing also makes it absolutely clear where everybody is situated, so that when we cut to close-ups, there is no doubt about who's looking at whom. This is a scene where every glimpse and phrase is vital, so the three minor characters are all in different physical positions. They could all have been seated around a table, but the scene plays much more clearly when one is lying down, another is seated, and the third is backed up to a wall.

A wide master should do more than give an overview of the scene. When planned well it can show the character dynamics and can also be staged so that the subsequent close-ups are easy to follow.

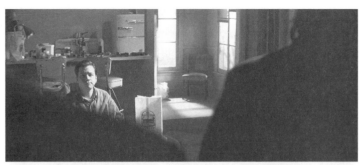

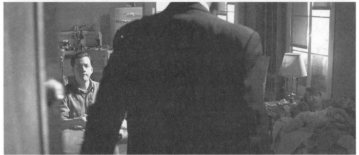

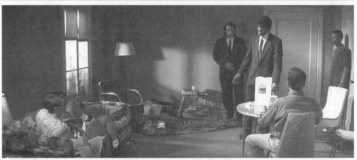

The close-up of Steers works because we've already established where everybody is with the wide master and seeing him clearly gives us the chance to see a brief glimpse of a character's fear.

The next few shots show the characters in isolation from everybody else in the room. This is a direct and deliberate contrast to the master and the rest of the scene that follows. This enables us to see the two nervous characters clearly, but it also helps to create a sense of anguish and isolation. If the group shots continued, we would feel some continuity. By breaking to close-ups and medium shots of individual characters, we experience an unexpected sense of tension. The young people in the room are not at all sure of what's going on. They aren't able to talk to each other or get away. This series of shots encapsulates that feeling of being alone and trapped at the same time.

When you've shown a room full of people, show the individuals one at a time, to create a sense of uneasy disconnection.

The next part of the scene takes place on the right side of the room (as seen in the master) but rather than cutting back to the master to make this transition, we go in to a close-up of Jackson and see him begin to move to that side of the room. Making this transition in close-up is more intimate and subtle than cutting back to the master.

If the action of the scene moves to another part of the room, indicate where the action is going by showing the character's motion in close-up before the cut.

The camera now moves lower so we feel the vulnerability of Whaley. When the shot opens the focus is on the characters in the background but Jackson immediately move in from the left, which makes sense given his movement in the previous close-up. He then takes up place in the center of the frame and the focus shifts to him as Travolta leaves to the left of frame.

In technical terms, Tarantino had a challenge here. He needed to show Travolta heading off to the kitchen area, while maintaining Jackson's dominance over Whaley. By putting the camera low and having Jackson walk in, Tarantino gives us a clear view of Travolta as he leaves and Jackson is able to stand so tall in the frame that the camera has to tilt up to him, and he looks overwhelming. This shot works well because Travolta and Jackson effectively swap places and it's their movement past each other that makes it absolutely clear where everybody is moving to.

When you need to move people to different parts of the scene, having them cross each other within the frame can actually clarify the geography of the scene.

The shot of Whaley serves to show us his reaction, as well as letting us see where Travolta has gone and roughly what he's doing back there in the kitchen. Jackson's arm can be seen on the left of frame. Earlier, Whaley was alone in this frame, but now the other characters are on either side of him, emphasizing that he is trapped.

Visual symbolism has a powerful effect on the audience. Keeping the camera low and having your character visually trapped between two villains keeps the tension high.

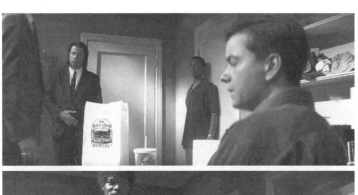

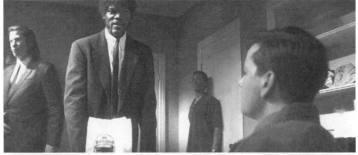

This scene is memorable for its tension and for the unusual violence that occurs at the end but, for the story to work, we need to see the suitcase and sense its importance. While the dialogue continues we cut to Travolta, casually slapping the suitcase down on the kitchen counter. Although we have seen the kitchen in the background, this is the first time we have effectively turned our back on the rest of the scene. We're concentrating solely on Travolta, and this hints that something important is about to be revealed.

If you are about to make a strong visual reveal, shoot in another part of the room, from a new angle.

The extreme close-up on the combination lock is a quick way of letting us know that Travolta knows the combination, but also makes it easier to cut to a medium close-up of him opening the case.

If a jump cut won't work, you can use an extreme close-up to bridge the gap between two similar shots.

The shot of Travolta is held for several seconds, before a brief cut back to Jackson in the master. The long close-up gives us time to take in Travolta's stunned reaction, which shows us the importance of the suitcase without a single line of dialogue having to tell us that it's important.

A few seconds of silence can work as well as several lines of dialogue.

We then cut back to the shot of Travolta in the kitchen as he closes the case, so that the relative normality of the scene is restored. The opening of the suitcase was so intense that it almost felt supernatural; a return to the wider shot helps bring him back down to earth so he can rejoin the others to play out the violent ending of the scene.

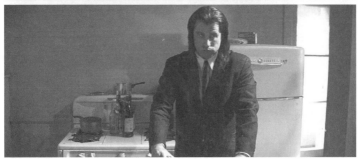

CHAPTER 10

GROUP CONVERSATIONS:
Kill Bill: Vol. 2

THIS SCENE IS A FLASHBACK that's already been described, and seen in glimpses, so we know what happens and who gets killed. The purpose of the scene is not to surprise us with an action scene but to show the characters enjoying their normal lives, while building a sense of unease. In order to feel the scale of the upcoming and inevitable tragedy, and empathize with Uma Thurman's quest for revenge, we need to see a casual and happy conversation but feel the storm coming.

To show this group conversation effectively, Tarantino opens the scene with an establishing shot of the chapel. We've already seen this chapel and know what happens there, so a lingering shot makes it clear that we're about to see the emotional heart of these two films.

If a key scene takes place at a recognizable location, when you return to that location, take your time over the establishing shot. A quick cut would imply you're just doing the basic job of showing where and when we are. A long take shows that the scene is significant.

Although Thurman looks quite small in the opening frame, she is in the center of the frame, showing that this is her scene, her life, and that she's surrounded by loved ones. Because Tarantino uses a wide lens, all the actors are relatively in focus and positioned deliberately so every face is visible. A character in the second row even delivers a brief line, helping to emphasize this group dynamic.

When you want to establish a small family gathering, or a group of close friends, make sure you can see all the faces at once.

The reverse shot is achieved by turning the camera directly around. All the shots of this couple are shot from this direct angle, and it never changes, but when we cut back to Thurman, we are closer and the framing has changed slightly. She remains almost central and is still the subject of the scene, but being closer allows us to connect with her more intimately, while the couple in the chapel remain distant and unfamiliar.

When two groups are talking, shoot the main characters from several positions, but shoot the minor characters from one angle. This will help the audience identify with the main characters.

The next shot is a wide shot of the two groups sitting across from each other, with Samuel L. Jackson out of focus as he addresses them. This increases the sense of unease, because two groups who are already struggling to converse are now interrupted by a distant figure. When we cut to the reverse, Jackson is far away but the focus remains on him, while Thurman and Christopher Nelson remain out of focus. This makes Jackson's character appear unusually intrusive. He doesn't seem threatening but is a powerful interruption and a portent of disruption.

When you've established a group conversation, cutting to an additional character who interrupts the flow of the scene can increase the sense of impending doom.

There are several more shots of the group conversation before we cut back to Jackson, clear and in focus for the first time. This is a brief but important moment. It's been established that this man will be killed, so seeing him calm and patient makes us more sympathetic than if he had only remained an eerie background presence.

When people are going to die in a scene, let the audience see them in close-up, to increase the sense of tragedy.

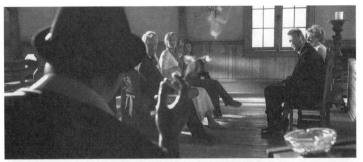

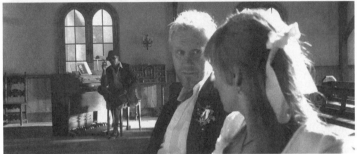

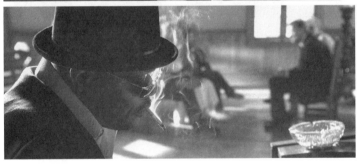

Simplicity is often the key to Tarantino's setups, because he doesn't do anything more complicated than he needs to. At this moment, we need to see Thurman talk to the girl on her left, so Tarantino moves the camera to the right. Rather than changing the lens, moving to a different angle, or dollying across, he just moves the camera across to shoot the part of the conversation we need to see.

When you've established a group scene well, with a wide master shot, and need to focus on another part of the group, just move the camera across.

After a few more shots that we've already seen, Thurman turns and we see four characters huddle in the frame. This framing gives us a clear view of Caitlin Keats, who is almost center frame. This is important because in the next shot, as Thurman stands and walks away, it is Keats who speaks. She's framed centrally and addresses the couple. This has the effect of shifting our attention to her and the group of innocent people that we know are about to be slaughtered.

We jump-cut to the wider shot, which lets us see Thurman leaving the group. This has a deeply unnerving effect because it's a corruption of the opening shot. The main character has effectively abandoned these innocents to their fate. Seeing Thurman disappear into the background also gets us ready for the next shot because we're eager to see where she's going and what happens next.

When trouble is coming, resist the temptation to show close-ups of the main character. Switching to shots of minor characters, and having your main character shrink in the frame, increases audience anticipation.

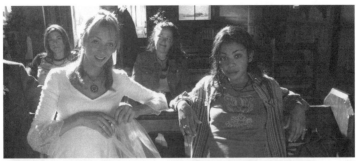

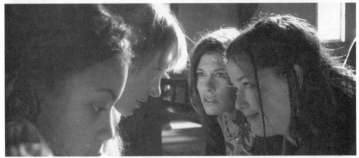

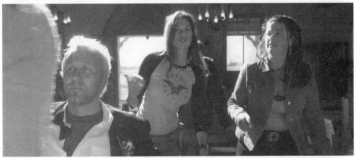

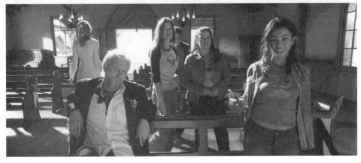

LOSING CONTROL:
Reservoir Dogs

THIS IS ONE OF Tarantino's most iconic scenes, and one that helped to make him. The end of the scene, where two people are pointing guns at each other (which probably wasn't even original at the time), has now been copied so often that it's become a cliché. Many action movies and cop shows echo this moment but there is still so much that can be learned from this scene.

The brilliance of Tarantino's directing is that he focused on the characters, not the guns. His job here was not to shoot some exciting action, but to reflect the mistrust and conflict of the script. The characters are losing control and that's what his camera moves capture.

The opening frame captures the moment, with Steve Buscemi almost stalking Harvey Keitel, whose anger is so pent up that he can't bring himself to make eye contact. This staging is far more powerful than if they were staring each other down.

When you want to show characters losing control, it is the way you shoot the relationship between the characters that makes the scene dramatic.

As the conversation gets more intense Keitel turns to face Buscemi in profile and then we cut to the medium close-up of him grabbing Buscemi by the lapels. A second later, and Buscemi has shaken him off and is alone in the frame. This brief moment of violence is not even a stunt, but comes across as the beginning of violence between these two. When Buscemi is alone in the frame it looks as though he has the upper hand and won't be dominated.

You can simulate violence through cutting to fast motion in close-up.

Although we feel that Buscemi may have the upper hand it is momentary because Keitel launches back into the frame and throws a punch behind Buscemi's head. We now see that the real reason Keitel was pushed out of the frame was so that his return would surprise us. If this fight had been shot with a wide lens or from a distance, it would look fake and weak. Being this close lets us sense the intensity of their proximity and gives us a surprise when Keitel reappears in the frame.

Let one character leave the frame for a moment, and the return will appear much more violent than it actually is.

After the punch, Buscemi throws himself backward a little. In reality, he probably remained standing, but we cut away fast enough for it to look as though he was punched to the ground. The next frame begins with an empty shot of the floor and Buscemi then lies down in the frame. If you watch this carefully, he lies down quite gently. This is not a stunt and he probably didn't even need padding beneath him but, with fast cutting, it looks as though he's been thrown there with a wild punch.

Cut from a punch to a shot of somebody lying down and, if you add the right sound effects and cut away quickly, it looks like a real stunt.

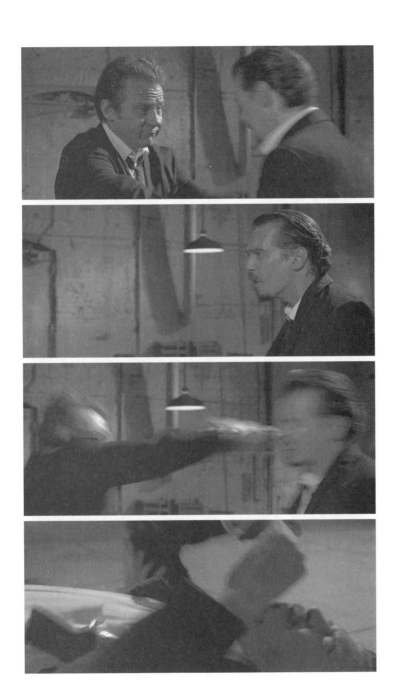

The next few seconds show how easy it is to give the impression of violence without endangering your actors. You should, of course, always use professional stunt coordinators for such scenes, but there's no need to complicate the shots too much.

In the opening frame, the camera dollies to the right, following Buscemi as he shuffles across the floor on his back. He moves to the right and slightly toward camera. At the same time, Keitel mimes kicking him. The mimed kicks appear realistic partly because they are hidden behind Buscemi's body and, therefore, don't need to make actual contact. They also work because the camera move, combined with Buscemi's movement across the floor, makes it look like the force of the kicks is actually pushing Buscemi across the floor. When we move with the action, we feel much more involved and the violence seems real.

Don't keep the fight in one place but move it across the room and dolly with the action.

Keitel moves around to the right so that when we cut to the close-up of Buscemi on the floor, Keitel is behind him from our point of view, ideally placed for fake kicks. The long lens makes the shot so tight on Buscemi that all he has to do is wriggle around on the floor and it looks as though Keitel's gently mimed kicks are making contact. We also cut to a brief shot of Keitel kicking hard. Buscemi would have been moved out of the way at this point and Keitel would merely be kicking the air or a bag. With the right sound effects, this sort of action looks extremely violent.

Shoot on the actor in close-up, while the other mimes kicks from behind, but make sure you keep these shots extremely short in the edit.

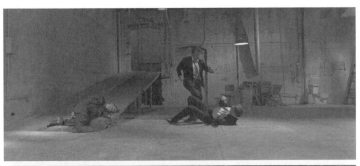

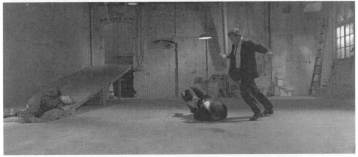

The sequence of kicks has built up such momentum that it feels like it's going to go on, so we're surprised to see Buscemi roll onto his back with his gun drawn. The shot is half a second long, which is why it works. We never see him unholster the gun, and the shot is so brief that we only glimpse what's going on. It works because it's shot from above, so we feel the same shock that Keitel's character would feel. It's the flash of a gun from nowhere.

When there's a sudden shift of power, surprise the audience. Shoot from the point of view of the one who was in control at the moment the power shifts to the other character.

In just over half a second we see Keitel's response. Again, the movement is too fast to actually follow, but there's enough visual information for us to sense what's happening. Cleverly, Tarantino gets Keitel to bring his gun out in an arc. He doesn't just whip it from his holster and point it down, but arcs it over his head and down the left of frame. This means that even though the shot is extremely brief, we can tell a gun has come out.

Sometimes fast action is used to hide what's going on, as with the mimed kicks. If there's something we need to see, however, make sure you actually capture the required visuals.

After this flurry of action we need to see exactly what's happened and what's at stake, so we get well over a second to see that the guns are pointing at each other. The sequence works because in two seconds we go from what looks like an obvious defeat, to a standoff that seems impossible to break.

When there's been a lot of fast movement, give the audience a moment to take in the conflict, which should be as visual as possible.

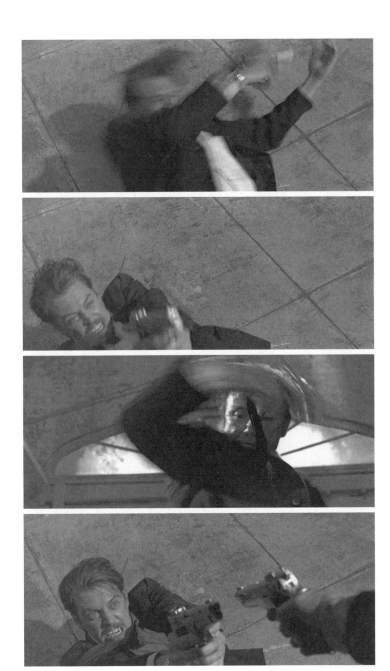

When this shot opens, there's no camera movement at first and Buscemi continues his dialogue. This gives us the impression of stasis, which is what we're meant to feel here. It's meant to seem that there's no way out of this situation. A few seconds later the camera begins to dolly away from the characters.

If you pause before a camera move, it will make a difficult situation seem even more impossible to resolve.

The initial effect of the backward dolly, as the two shrink in the frame, is to make their dilemma seem even larger. It's as though they're being swallowed up by the world around them. Both are powerless.

Dolly away from characters, to see the space around them, and you diminish their power.

As the dolly move continues we see Michael Madsen appear on the right of frame. He speaks, and then the other characters look across at him, and the tension is broken. Sometimes the only way to get out of a situation is to have another character get involved.

Rather than showing that character walk into the scene, it's more interesting to move the camera back and show the character is already there.

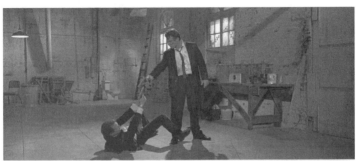

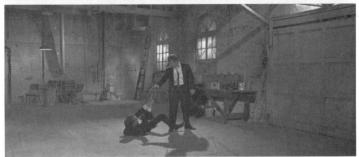

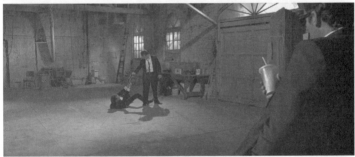

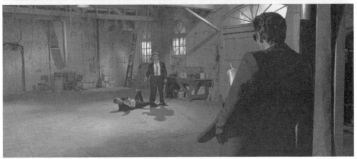

CONCLUSION

I hope that, having read this book, your eyes will have been opened to a way of filmmaking that means you will never have to copy Tarantino.

Some of the ideas shown here are used by Tarantino over and over again, in film after film, and they never lose their potency. You can apply these to your own scenes, and they will improve the visual impact of your scenes.

One of Tarantino's key skills is efficiency. When you read a chapter in this book, watch the scene and you will see how much information is conveyed with a minimal number of camera setups. When you're planning your next shoot, see if you can capture the scene with three or four carefully planned setups.

There are many more secrets in his films, and I strongly recommend that you find every scene you like and try to decode the magic. Watch his movies with the sound switched off, or you'll get drawn into the story. Take note of the framing, the way characters move in the scenes, and where the cuts occur.

Using the knowledge you've learned here, work out why those scenes succeed. When you can do that, your ability to create new scenes will improve enormously, and you can start working on your own masterpiece.

ABOUT THE AUTHOR

Christopher Kenworthy has worked as a writer, director, and producer for the past fourteen years. He directed a feature film, along with many music videos and commercial projects. Currently he is focused on writing.

Christopher is the author of the best-selling *Master Shots Vol. 1*, *Master Shots Vol. 2*, and *Master Shots Vol. 3: The Director's Vision*. He is also the author of two novels and many short stories.

Born in England, he currently lives in Australia with two daughters and the actor Molly Kerr.

www.christopherkenworthy.com

SHOOT LIKE SPIELBERG
The Visual Secrets of Action, Wonder and Emotional Adventure

Christopher Kenworthy

Spielberg makes his audience feel something, whether he's shooting a kids' adventure, a dramatic chase, or the darkest war scene. The auteur always employs a core set of techniques that make each shot crystal clear and evoke the most intense emotions from the audience. This book shows you how. From tension to tear-jerker, these moves will make your scenes memorable enough to be talked about for years to come.

Stephen Spielberg directs films that cover everything from childhood dreams to the horrors of war. He always hones in on the emotional center of a scene. This book unravels the secrets of his core techniques, and shows how you can use the same simple camera moves and setups to make your films full of wonder, thrills, and emotion.

CHRISTOPHER KENWORTHY worked as a writer, director, and producer for fourteen years. He directed a feature film, along with many music videos and commercial projects. Currently he is focused on writing.

Christopher is the author of the internationally bestselling *Master Shots* series (three volumes). He also shot, wrote, and created the groundbreaking *Master Shots* eBook series, available on the Apple iBook platform. www.mwp.com

Born in England, he currently lives in Australia with two daughters and the actor Molly Kerr.

$15.95 · 144 PAGES · ORDER #219RLS · ISBN 9781615932283

SHOOT LIKE SCORSESE:
The Visual Secrets of Shock, Elegance, and Extreme Character

Christopher Kenworthy

Without the right camera moves, an actor's performance is hidden. Scorsese is a great storyteller, but his greatest skill is telling a visual story that makes room for the actor's performance. This means that whatever actors you are working with, you can use the Scorsese techniques to make every performance shine, whether you're shooting subtle romance or tense confrontations.

Martin Scorsese directs films that range from the subtlest studies of relationships to violent gangster movies, with characters who are driven to the extremes of their personality. This book looks at Scorsese's key techniques, showing how he uses space, framing, and a strong sense of direction, to ensure that your films are brimming with tension, shock, and emotion.

CHRISTOPHER KENWORTHY worked as a writer, director, and producer for fourteen years. He directed a feature film, along with many music videos and commercial projects. Currently he is focused on writing.

Christopher is the author of the internationally bestselling *Master Shots* series (three volumes). He also shot, wrote, and created the groundbreaking *Master Shots* eBook series, available on the Apple iBook platform. www.mwp.com

Born in England, he currently lives in Australia with two daughters and the actor Molly Kerr.

$15.95 · 144 PAGES · ORDER #SCORSESE · ISBN 9781615932320

24 hours | 1.800.833.5738 | www.mwp.com

I'LL BE IN MY TRAILER
THE CREATIVE WARS BETWEEN
DIRECTORS & ACTORS

JOHN BADHAM AND CRAIG MODDERNO

What do you do when actors won't do what you tell them to? Remembering his own awkwardness and terror as a beginning director working with actors who always had their own ideas, director John Badham (*Saturday Night Fever, WarGames, Stakeout, The Shield*) has a bookload of knowledge to pass along in this inspired and insightful must-read for directors at all levels of their craft.

Here are no-holds-barred out-of-school tales culled from celebrated top directors and actors like Sydney Pollack, Michael Mann, John Frankenheimer, Mel Gibson, James Woods, Anne Bancroft, Jenna Elfman, Roger Corman, and many more that reveal:
- The 10 worst things and the 10 best things you can say to an actor
- The nature of an actor's temperament and the true nature of his contributions
- The nature of creativity and its many pitfalls
- The processes of casting and rehearsal
- What happens in an actor's mind during a performance
- What directors do that alienates actors
- And much more

"Most young directors are afraid of actors. They come from film school with a heavy technical background, but they don't know how to deal with an actor. Even many experienced directors barely talk to their actors."
> — Oliver Stone, Director, *JFK, Platoon, Wall Street, Born on the Fourth of July*

"Directors have needed a book like this since D. W. Griffith invented the close-up. We directors have to pass along to other directors our hard-earned lessons about actors. Maybe then they won't have to start from total ignorance like I did, like you did, like we all did."
> — John Frankenheimer, Director, *The Manchurian Candidate, Grand Prix, Seconds*

JOHN BADHAM is the award-winning director of such classic films as *Saturday Night Fever, Stake Out*, and *WarGames* and such top TV shows as *Heroes, The Shield*, and *Crossing Jordan*. Badham currently is the DeMille Professor of Film and Media at Chapman University.

CRAIG MODDERNO is a contributing writer to the *New York Times*.

$26.95 · 243 PAGES · ORDER NUMBER 58RLS · ISBN: 9781932907148

MASTER SHOTS E-BOOKS

Introducing a new series of enhanced eBooks with HD video and audio

Master your shots in a new way.

This new series of eBooks with HD video provides a visual feast for movie fans and filmmakers alike. Based on the best-selling linee of books by Chrristopher Kenworthy, Master Shots divulges the great directors' most thrilling secrets, teaching the techniques you need to pump up the passion and style of your film or video project.

Now available on all Mac Desktops, Laptops and iPads (Maverick OSX or higher required).

Click on www.mwp.com to see trailers, sample pages, and purchase for only $39.99/each.

THE MYTH OF MWP

In a dark time, a light bringer came along, leading the curious and the frustrated to clarity and empowerment. It took the well-guarded secrets out of the hands of the few and made them available to all. It spread a spirit of openness and creative freedom, and built a storehouse of knowledge dedicated to the betterment of the arts.

The essence of the Michael Wiese Productions (MWP) is empowering people who have the burning desire to express themselves creatively. We help them realize their dreams by putting the tools in their hands. We demystify the sometimes secretive worlds of screenwriting, directing, acting, producing, film financing, and other media crafts.

By doing so, we hope to bring forth a realization of 'conscious media' which we define as being positively charged, emphasizing hope and affirming positive values like trust, cooperation, self-empowerment, freedom, and love. Grounded in the deep roots of myth, it aims to be healing both for those who make the art and those who encounter it. It hopes to be transformative for people, opening doors to new possibilities and pulling back veils to reveal hidden worlds.

MWP has built a storehouse of knowledge unequaled in the world, for no other publisher has so many titles on the media arts. Please visit www.mwp.com where you will find many free resources and a 25% discount on our books. Sign up and become part of the wider creative community!

Onward and upward,

Michael Wiese
Publisher/Filmmaker